Y0-BRD-354

SOMEWHERE
in a Small Town

T. STACY HELTON
photography by Cayce Callaway

LONGSTREET PRESS, INC.
Atlanta, Georgia

Published by Longstreet Press, Inc.
A subsidiary of Cox Newspapers,
A subsidiary of Cox Enterprises, Inc.
2140 Newmarket Parkway
Suite 122
Marietta, GA 30067

Printed in the United States of America
1st printing 1997
Library of Congress Catalog Card Number: 96-79801
ISBN 1-56352-366-3

Book and jacket design by Jill Dible

*To the memory of my grandmothers, Inez Hyde and
Florence Helton, and the bygone days of childhood in
Ringgold, Georgia, my small town*

———◆———

I would like to acknowledge the support of several important
people: my editor, Suzanne Bell, for believing in this project
from its conception, as well as the talented staff at Longstreet
Press, who fueled the vision with their unabashed optimism;
and my parents, who taught me the values that I hope this book
conveys. Special thanks to my assistants, Loreen Sander and
Beth Frye, as well as my New York triumvirate, Lee Boudreaux,
Sue Gaudio, and Shira Levine.

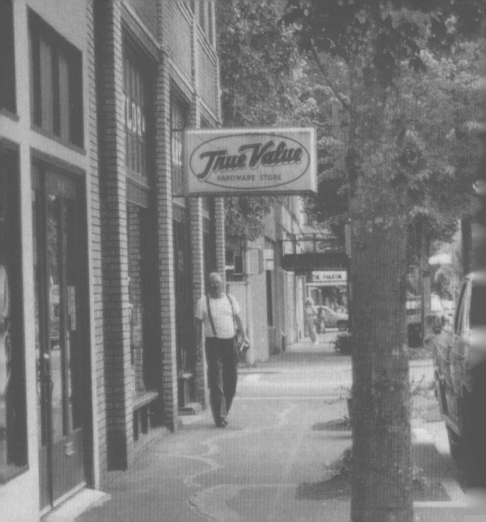

introduction

There are certain images of my small town that still haunt me. If it is true that we as a people live our lives in a particular nostalgia, then for me, my small town stands out as a perfect picture from my childhood imagination. I can remember being able to ride my bike from one end of town to the other, stopping along the way to visit with friends and relatives, shopkeepers and tradesmen. In the early evenings, it was a big deal to see who could catch the most lightning bugs, allowing their spectacular bodies to guide our way back home. Friday nights in the fall, the community cheered in concert as the high school football team played beneath the mountains; in the distance a lonely train rumbled from one town to the next, oblivious to whether the hometeam was winning.

Saturday mornings were a time for errands; my grandmother held my hand as we walked from the bank to the post office to the hardware store and visited with each acquaintance concerning the latest piece of news. The afternoon had its own punctual sounds: the buzz of lawnmowers, mothers' sing-song calls to round up their children before darkness fell. I can remember a windy March afternoon when I had the kite that flew the fastest and the longest, somehow dodging the telephone lines that carried news to and fro. Sunday mornings were full of the peals of

church bells, announcing that worship in various churches was soon to begin.

As I became older, the familiar sounds of my life became the voices of my school, where I learned side by side with the sons and daughters of my father's classmates. Cold winter recesses crackled with the exuberant laughter of children struggling over jump ropes and kickballs, trying to ignore the bell that would bring them closer to math. Prom nights with the smell of orchids, the flash of a camera that would frame an awkward moment forever on the living-room wall. A first kiss, stolen without a moment's thought, lingering in the recesses of my mind.

The decision to leave is the hardest one I have ever had to make, but I know that I'll go back, eventually to be buried with all of my family that made me who I am.

These are some of the images of small-town life that I have been carrying around with me. With those fortunate enough to be blessed with the kinship, values and emotions of a small town, I share this book of memories.

T. Stacy Helton
Ringgold, Georgia
Christmas 1996

SOMEWHERE
in a Small Town

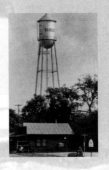

Somewhere in a Small Town...

—•—

a pigtailed girl is hiding a stray puppy,
with little success.

—•—

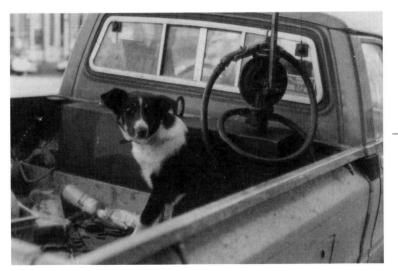

Somewhere in a Small Town...

the druggist makes a delivery
on his way home.

—•—

the neighborhood brings food
to celebrate a new birth.

—•—

young couples are carving
their initials in an oak tree.

an old dog is taking a quick nap
in the post office lobby.

—•—

parents are wearing the team
colors to the game.

—•—

the banker inquires about a customer's
garden during a dry spell.

Somewhere in a Small Town...

—•—

a grandmother is
canning tomatoes for the winter.

—•—

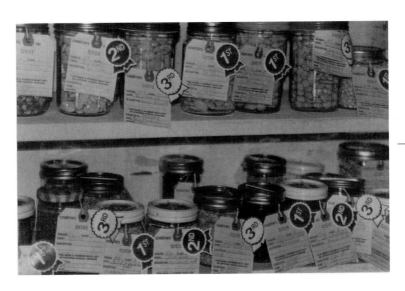

Somewhere in a Small Town...

brothers and sisters are
playing in the water sprinkler.

—•—

a local band amplifies the
Legion Hall at the graduation party.

—•—

sun-dried laundry smells
fresh just off the line.

Somewhere in a Small Town...

a small boy is making the Big Catch
with his father's mitt.

—•—

flags line the streets on Memorial Day.

—•—

ghosts and goblins bob for apples
at the Halloween carnival.

—•—

peaches and melons are in season
at the corner stand.

—•—

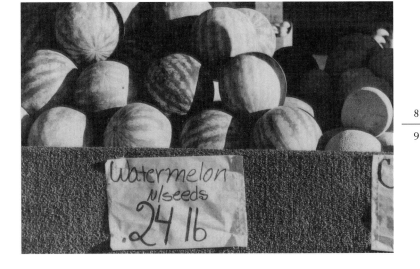

watermelons are split right on
the ground at the church picnic.

—•—

a young man stops to help the
barber's wife with her packages.

—•—

the mayor can be found fishing
most Wednesday afternoons.

Somewhere in a Small Town...

children are jumping into
colorful piles of autumn leaves.

—•—

a softball field exudes the aroma
of fresh-cut grass.

—•—

little girls are having a tea party
beneath a lazy magnolia tree.

Somewhere in a Small Town...

—•—

the school band plays for the
Christmas tree lighting.

—•—

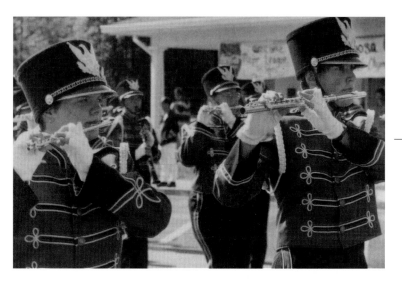

Somewhere in a Small Town...

the baker clears his home kitchen to begin
work on another special wedding cake.

—•—

a second-grade class is saying
the Pledge of Allegiance.

—•—

amateur fireworks are
dazzling a summer sky.

Somewhere in a Small Town...

someone is calling just to visit
a while on the phone.

—•—

dead tree limbs snap in strong hands
to become winter kindling.

—•—

a fireman is checking on
an elderly shut-in.

Somewhere in a Small Town...

—•—

neighbors are helping
to repair a barn.

—•—

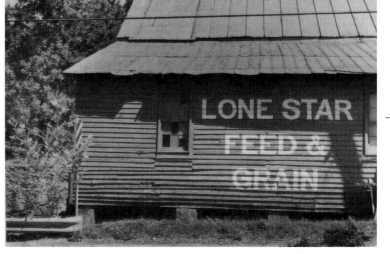

Somewhere in a Small Town...

blackberry season brings forth
a brigade of pails and buckets.

—•—

a rising creek is cause for concern.

—•—

children are leaving pennies on the
train track, to be retrieved later.

Somewhere in a Small Town...

the firehouse dog waits for his scrap
at the butcher's backdoor.

—•—

the town hall is being prepared for
a visit by the governor.

—•—

a grandfather is teaching his grandson
how to whittle.

Somewhere in a Small Town...

—•—

the community awaits front-page
news in the weekly paper.

—•—

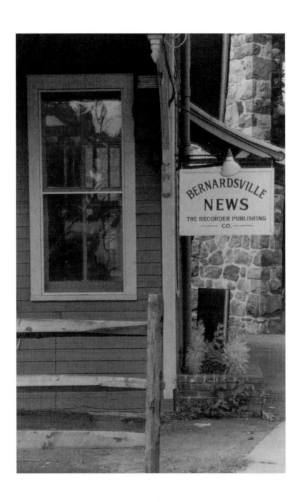

Somewhere in a Small Town...

everyone goes to the
high school graduation.

—•—

streets are named for local families
who go way back.

—•—

two brothers are racing sailboats
down the backyard stream.

Somewhere in a Small Town...

conversations are drifting off front
porches in the cool of an evening.

—•—

a child places flowers on
a grandparent's grave.

—•—

a winding creek makes an
inspirational sight for a baptism.

Somewhere in a Small Town...

—•—

the drug store features fountain sodas
and homemade sandwiches.

—•—

Somewhere in a Small Town...

a cat sits under a bird bath,
hoping to get lucky.

—·—

a carpenter is showing the 4-H club
how to build a bookcase.

—·—

children are building teepees
out of corn stalks and husks.

a blueberry pie is
cooling on the windowsill.

—•—

the aroma of a chestnut tree
accents an autumn afternoon.

—•—

schoolchildren are doing reports on
Tom Sawyer and Huck Finn.

Somewhere in a Small Town...

—•—

an unexpected visitor
is welcome anytime.

—•—

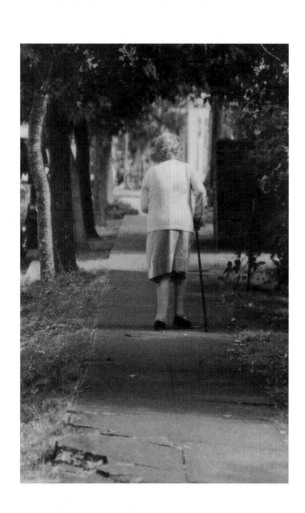

Somewhere in a Small Town...

people keep salt by the porch
steps to deter snails and slugs.

—•—

the librarian is displaying books for
the summer reading program.

—•—

an owl's call is questioning the
arrival of a new morning.

Somewhere in a Small Town...

a local candidate is
shaking hands at a fish fry.

—•—

an old, empty house provides
ghost stories for generations.

—•—

a young horse-lover reads
Black Beauty for the first time.

Somewhere in a Small Town...

—•—

an eager congregation will
house the visiting church choir.

—•—

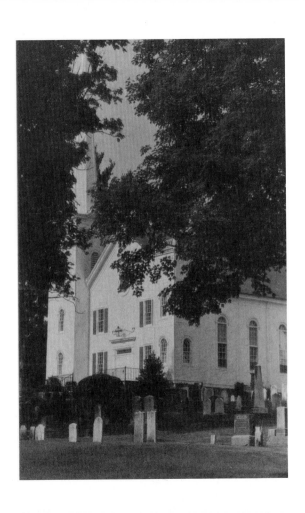

Somewhere in a Small Town...

a father and son are drifting
off to sleep in a hammock.

—•—

even the messiest child
is clean on Picture Day.

—•—

the hayride proves as much fun for
the adults as the children.

Somewhere in a Small Town...

carolers' songs slip through
the air on a December eve.

—•—

a pond becomes an instant swimming
pool after a hot day in the field.

Somewhere in a Small Town...

—•—

a Friday night football game
empties every house.

—•—

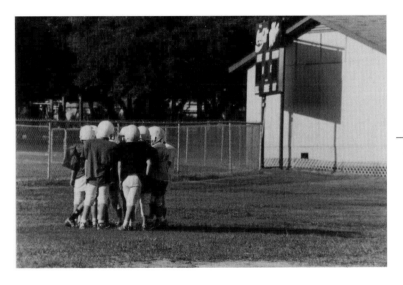

Somewhere in a Small Town...

the largest pumpkin wins a prize.

—•—

little hands and buckets of mud
can briefly dam a stream.

—•—

barbecue is still best with
a Mason jar of iced tea.

Somewhere in a Small Town...

auditions for *Our Town* bring out
plenty of amateur Georges and Emilys.

—•—

the volunteer firemen are
having a holiday toy drive.

—•—

a box turtle is looking
to cross the road.

Somewhere in a Small Town...

—•—

a deacon is watching the minute
hand creep toward 12:00.

—•—

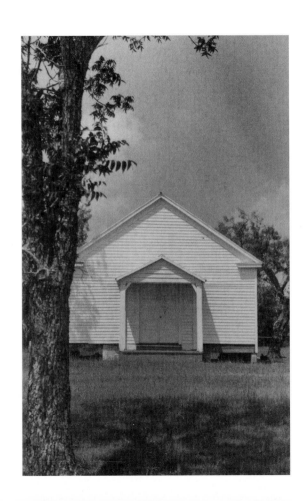

Somewhere in a Small Town...

locals gather at the coffee shop
for pie and gossip.

—•—

kittens will always
have a good home.

—•—

an early morning angler is busy
digging bait from the backyard.

Somewhere in a Small Town...

homemade peach ice cream
is churning on a back porch.

———•———

spring weather invites Sunday
school classes to meet outdoors.

———•———

neighborhood boys are
mowing lawns for pocket money.

Somewhere in a Small Town...

—•—

children are excited about the state
fair weeks before it comes.

—•—

Somewhere in a Small Town...

a child is cradling a bird's nest
found beside a cedar tree.

—•—

eggs collected in the hen house
are served fresh for breakfast.

—•—

young boys are seeking treasures in
a cave just past the old wooden bridge.

Somewhere in a Small Town...

seldom-seen loved ones are
arriving home for Thanksgiving.

—•—

a frozen pond can fulfill
a future ice skater's dreams.

—•—

the longest line at the school fair
is for hot-air balloon rides.

Somewhere in a Small Town...

—•—

coffee refills are free
at the diner on the square.

—•—

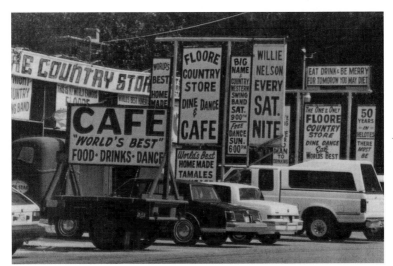

Somewhere in a Small Town...

the first winter chill brings
homemade quilts out of the trunk.

—•—

a tractor on Main Street is
moving at a snail's pace.

—•—

competition is fierce for
the new jump rope at recess.

Somewhere in a Small Town...

the local variety store is having
a sale on potted plants.

—•—

a child is discovering a
good book on a rainy afternoon.

—•—

fresh beans are snapped on
the steps before dinner.

Somewhere in a Small Town...

—•—

motorcades and bright parades
celebrate down-home days.

—•—

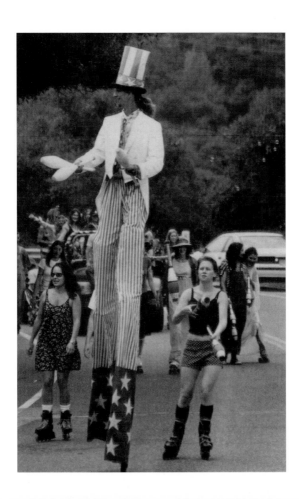

the cat makes a ruckus before
being put out for the night.

—·—

gathered farmers let down truck gates
to sell produce picked that morning.

—·—

babies are born just down the road from a
grandmother's wise care.

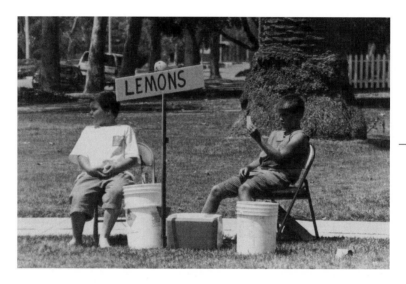

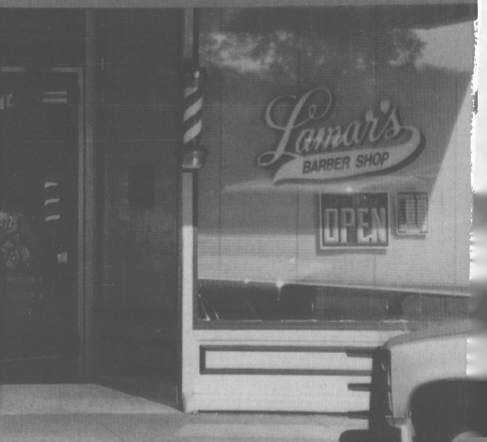